Painting with Watercolours

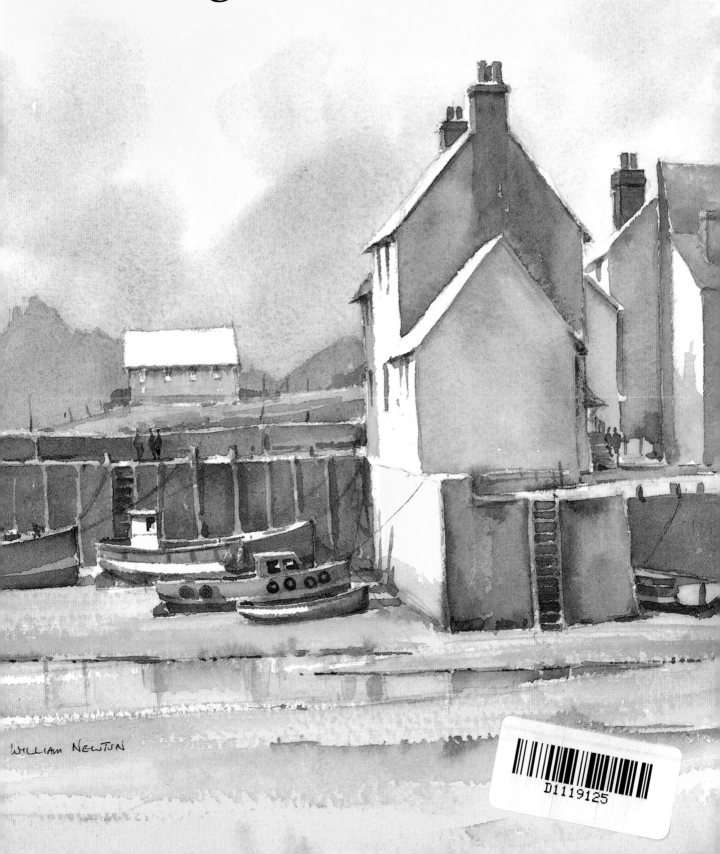

WILLIAM NEWTON

D1119125

For my wife, Susan,
and my sons, Russell and Barnaby,
for their help and support.

Painting with
Watercolours

WILLIAM NEWTON

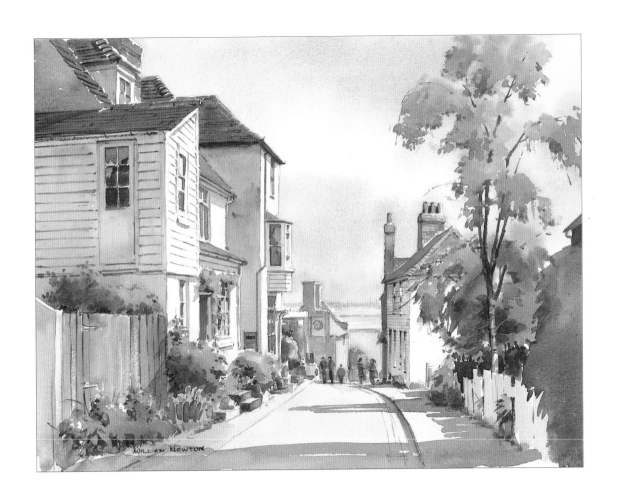

SEARCH PRESS

First published in Great Britain 1999

Search Press Limited
Wellwood, North Farm Road,
Tunbridge Wells, Kent TN2 3DR

Reprinted 2000, 2001 (twice), 2002 (three times), 2004

Text copyright © William Newton 1999

Photographs by Search Press Studios
Photographs and design copyright © Search Press Ltd. 1999

All rights reserved. No part of this book, text, photographs or
illustrations may be reproduced or transmitted in any form or by
any means by print, photoprint, microfilm, microfiche,
photocopier or in any way known or as yet unknown, or stored in
a retrieval system, without written permission obtained
beforehand from Search Press.

ISBN 0 85532 898 3

The Publishers and author can accept no responsibility for any
consequences arising from the information, advice or instructions
given in this publication.

The publishers would like to thank Winsor & Newton for
supplying many of the materials used in this book.

Suppliers
If you have difficulty in obtaining any of the materials and
equipment mentioned in this book, then please write to the
Publishers at the address above, for a current list of stockists,
including firms who operate a mail-order service. Alternatively,
write to Winsor & Newton requesting a list of distributers.

Winsor & Newton, UK Marketing
Whitefriars Avenue, Harrow, Middlesex HA3 5RH

Publisher's note

All the step-by-step photographs in this book feature the
author, William Newton, demonstrating how to paint with
watercolours. No models have been used.

There is reference to sable hair and other animal hair
brushes in this book. It is the publishers' custom to
recommend synthetic materials as substitutes for animal
products wherever possible. There are now a large number
of brushes available made from artificial fibres and they are
satisfactory substitutes for those made from natural fibres.

Colour separation by Graphics '91 Pte Ltd, Singapore
Printed in Spain by Elkar S. Coop. 48180 Loiu (Bizkaia)

Front cover
Down to the River
230 x 190mm (9 x 7½in), 300gsm (140lb) NOT
*The subject of this painting is the strong, late-
afternoon sunlight that streams across the road,
striking the cottage walls and making long shadows.*

Page 1
Low Water in the Harbour
250 x 320mm (9½ x 12½in), 640gsm (300lb) NOT
*There is a wealth of subject matter to be found around
the coast, especially old harbours such as this.*

Page 3
Old High Street
365 x 280mm (14¼ x 11in), 300gsm (140lb) NOT
*Subjects such as this street, with its jumbled and
mixed architecture, trees, foliage and strong sunshine,
are irresistible to me and many other painters.*

Opposite
The Old Barn
290 x 190mm (11¼ x 7½in), 300gsm (140lb) NOT
*This lovely old farm building is the perfect subject for a
small study in harmonising tones.*

Contents

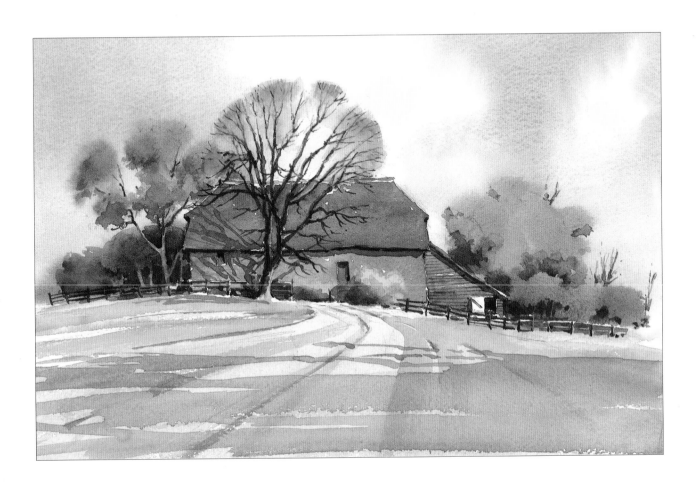

Introduction

Nothing quite compares with the transparency, luminosity and sheer beauty of a well-painted watercolour. I have been a full-time artist for over twenty years and I have painted (and sold) a great number of watercolours, so this is an important medium to me and occupies a large part of my painting time.

I also work in oils, and I am often asked 'Which medium is the most difficult to use – watercolour or oil?'. My answer is that, in their own way, each can be difficult to master but both can be extremely rewarding. When painting there is very little at stake, and the worst that can happen is that you spend some enjoyable and absorbing time trying.

For a painting to be successful, it must stimulate the viewer and make its own statement, and its various elements must work together to form a cohesive whole. Therefore, you have a perfect right to use as much license as necessary to create a well-balanced composition. You can introduce cloud formations into a clear sky, alter the shape and position of trees and leave out objects that might spoil the scene. Above all, you can manipulate the mood and atmosphere by varying the tonal values and balance of colours used.

In this book, I tell you about how I use colour and how to compose a painting. I illustate some basic techniques and I have included four step-by-step demonstrations. I have also included a selection of paintings to inspire you . . . so let us get down to the nitty gritty.

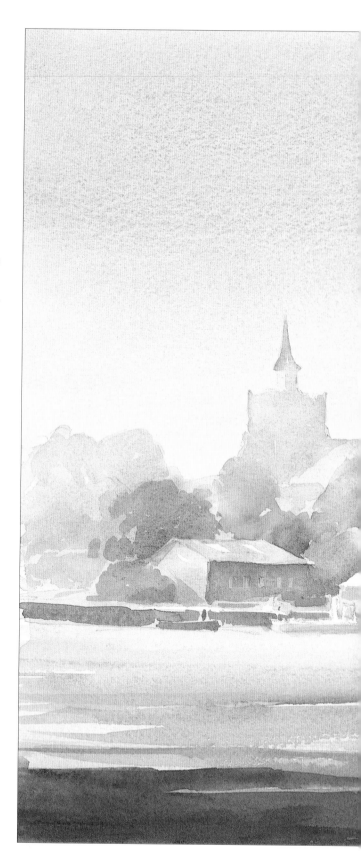

Misty Morning

365 x 275mm (14¼ x 10¾in), 300gsm (140lb) NOT

This is very much an aerial perspective painting, with the strong tones of the barge standing out against the softened, blended background. It breaks the rules of good composition in that the mast breaks out of the picture through the middle of the sky. However, since the overall 'weight' of the barge is slightly off centre, I feel it works well enough.

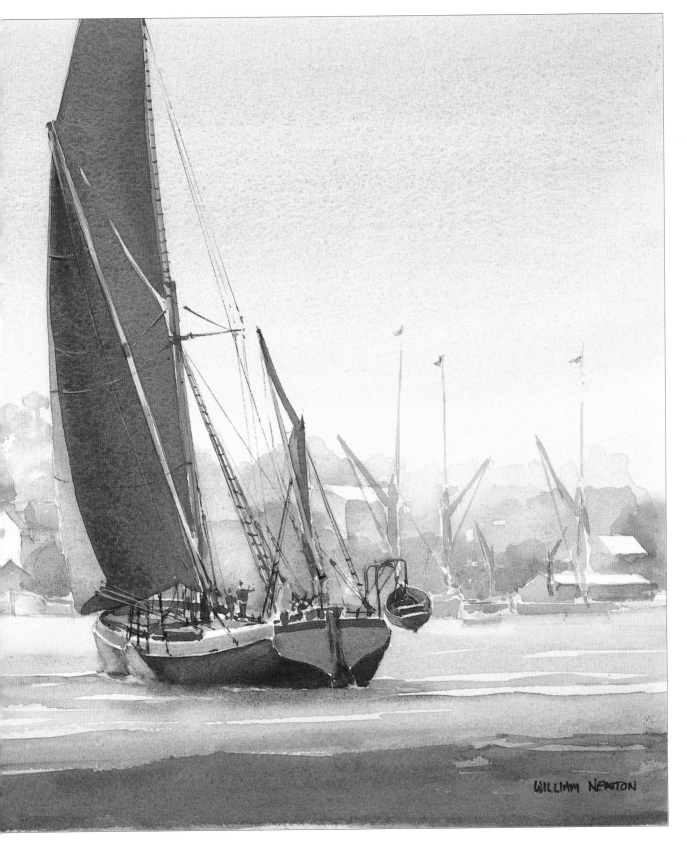

WILLIAM NEWTON

Materials

Art suppliers hold vast ranges of paints, brushes, papers and other artist's equipment, and it can be quite daunting for the beginner to decide on what to buy. Rest assured, your initial outlay for materials need not be overly high as it is perfectly possible to create a beautiful painting with just one colour and one brush. Here, I mention all the materials and equipment that I use, but you can start with just a few essentials and then add more items as you become more addicted.

Note If you want to take up watercolour painting fairly seriously, always try to buy the best quality materials that you can afford.

My colour palette

A portable palette is essential for outdoor work but at home or in the studio an old white dinner plate would be perfectly suitable for mixing on. My paintings are usually created with a fairly small number of colours, but I like to have the option of making several limited palettes for different subjects. My normal palette holds the twelve colours listed below (see also page 12) – some I use regularly, others not so often. Each colour has its own place in the palette so that I know exactly where each is. I also use a tube of sepia for monochrome paintings.

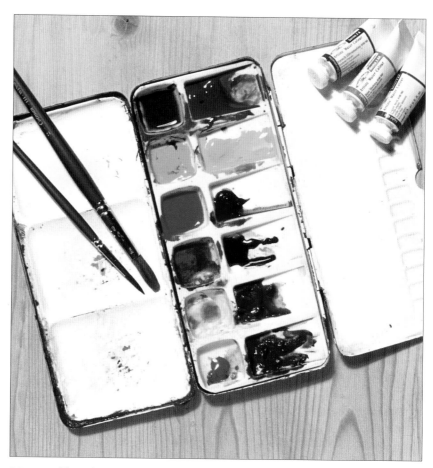

Note Mix your washes before you start a painting so that they can be transferred to the paper when needed. Stopping to mix a colour half way through a wash can cause problems.

My portable palette

Left-hand trays, from top to bottom: French ultramarine, cadmium yellow, cadmium red, light red, raw sienna, cerulean blue.

Right-hand trays, from top to bottom: cobalt blue, lemon yellow, brown madder, Winsor blue (green shade), burnt sienna, burnt umber.

Paints

Watercolour paints are available in tubes or pans. I prefer to use tubes as the colour is softer and wetter, and dissolves more readily to make washes. Since you can start painting with just a few colours, the expense of artists'-quality paints will prove a sound investment. These colours are purer and stronger and, in the long run, they work out more economical to use than cheaper qualities. The difference in cost per painting is negligible. I have often been frustrated by students who turn up with an ancient paint box with numerous pans of rock hard, unidentifiable colours of indeterminate origin. If this sounds familiar, please throw them away and start afresh!

Brushes

There is a wide variety of watercolour brushes available. Sable brushes can be quite expensive, but they hold water very well and are a joy to use. However, the synthetic/sable blend brushes are also excellent and relatively inexpensive.

I use a 38mm (1½in) flat brush, or a large squirrel mop, for damping down the paper and for larger washes, and a 19mm (¾in) flat brush for general blocking in. I also use round brushes, Nos. 5, 10, 12 and 14, for general work and, most essentially, a No. 1 rigger (a long-haired brush) for fine detail.

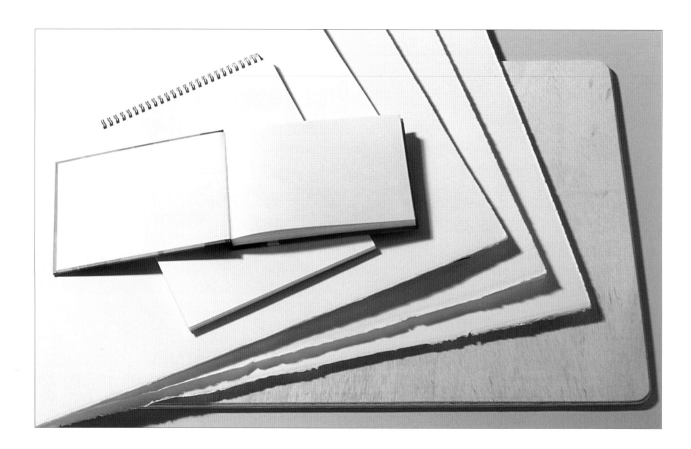

Papers

Watercolour paper is available in different sizes, surface finishes and weights (thicknesses). Again, always use good quality paper.

You can buy paper in sheet form, as spiral bound pads or in blocks. Sheets usually measure 760 x 560mm (30 x 22in), but the pads and blocks are available in a variety of sizes.

There are three standard types of surface finish: Hot Pressed (HP) has a smooth surface; NOT/Cold Pressed has a medium texture; and Rough has a heavy texture. However, surface finish does vary a great deal from make to make.

Watercolour paper is also made in a number of weights which range from 190gsm (90lb) up to 640gsm (300lb) or even more. The 190gsm paper is rather thin and would certainly require stretching. The most widely used weight is 300gsm (140lb) and, if you use a quarter sheet 380 x 280mm (15 x 11in), it will not need stretching. For larger paintings I recommend using a heavier paper.

I always carry an A4 (11¾ x 8¼in) cartridge-paper sketch book in my car and a smaller one in my coat pocket, together with a couple of pencils (2B and 4B). I use these to make small sketches and to record information about such things as direction of light, shape and position of shadows – sometimes these small drawings become large studio paintings.

Painting board

This needs to be about 50mm (2in) larger than the size of paper and rigid enough to resist flexing when in use, or if used for stretching paper. My board is 12mm (½in) thick and measures 610 x 430mm (24 x 17in), which is large enough to take a 560 x 380mm (22 x 15in) sheet of paper. Plywood will do, but there are some excellent foam boards available which are stiff yet very lightweight – when out of the studio, the weight of your equipment is a factor to be taken into account.

Easel

The choice depends on your workspace, or whether you are painting indoors or outdoors. Table easels are useful when working on smaller pictures. Sturdy box easels are also available. I prefer to use a sketching easel, which is light and portable, and can be worked on outdoors and indoors.

Other items

Water container Almost anything can be improvised for this purpose, but it needs to be large enough to hold 1litre (2pt) of water. If it has a handle, it can hang below the easel.

Masking tape or clips I use masking tape to secure the paper to my painting board, but large clips will work just as well.

Pencils I use 2B and 4B for drawing on watercolour paper. Their soft lead will not damage delicate paper surfaces.

Putty eraser Used with care, this should not damage paper when erasing preliminary pencil lines. However, use it as little as possible.

Hairdryer Useful in the studio if you are in a hurry, but only use it for final drying.

Craft knife For sharpening pencils.

Absorbent paper Ideal for cleaning your palette and for drying brushes.

Gummed paper tape Used for stretching lightweight paper.

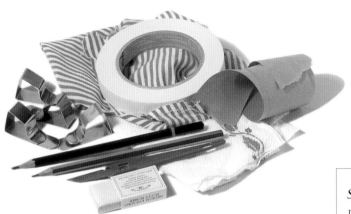

Stretching watercolour paper
I always use heavy paper that does not require stretching. However, stretching paper is simply a matter of thoroughly wetting it and then securing the wet sheet to a stiff board with gummed paper tape and leaving it to dry before starting to paint.

Using colour

Throughout my painting life I have experimented with new colours, mixes and techniques, so my current palette of twelve colours has evolved over the years. I am sure it will continue to change, but that is a subject for the future. Below I have included a small graded wash of each colour, primarily to show the tonal values you can achieve.

The three colours in the first column form the limited palette for the demonstration on page 26, and it is quite surprising just how many colours and variations of tone can be created from these.

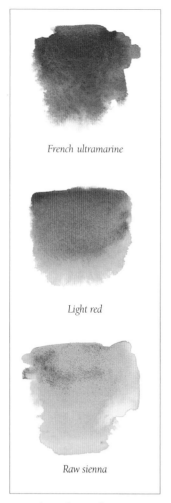

French ultramarine

Light red

Raw sienna

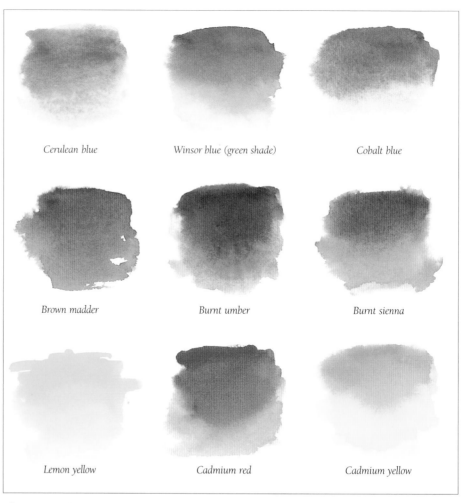

Cerulean blue

Winsor blue (green shade)

Cobalt blue

Brown madder

Burnt umber

Burnt sienna

Lemon yellow

Cadmium red

Cadmium yellow

I use these three colours in almost all of my paintings.

These nine colours complete my full palette. Some I use regularly, others more sparingly.

12

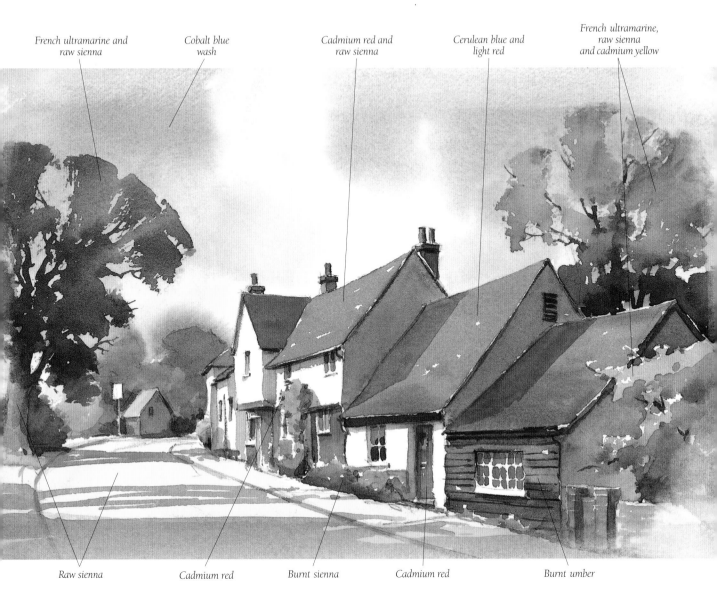

French ultramarine and raw sienna

Cobalt blue wash

Cadmium red and raw sienna

Cerulean blue and light red

French ultramarine, raw sienna and cadmium yellow

Raw sienna

Cadmium red

Burnt sienna

Cadmium red

Burnt umber

Mixing colours

Colour mixing is the key to creating a good painting. I cannot stress enough how important it is to get to know your colours. Find out how dilution with clean water affects the tonal values. Mix colours together in various ratios and note the different shades you can obtain – it may surprise you how many variations of tone and colour can be created from just red, yellow and blue.

You should aim at being able to create exactly the right colours and tones you need for a particular subject, first time round, without too much correcting. This way you are much more likely to produce clean, fresh and transparent paintings. So, the rule is practise, practise and more practise!

Above is a finished painting that I have annotated with the colours and mixes that I used to paint it. I hope you will find this more explanatory than the usual colour mixing wheel.

Basic techniques

Having equipped yourself, the first thing to do is to get used to handling your tools and materials. It is well worth using up a couple of sheets of watercolour paper to practise the following techniques; to have fun exploring the characteristics of pigments; and to get used to different brushes.

Although this medium is called watercolour, you need to control the amount of water used. Rinse out your brush regularly in clean water – before, during and after working a particular area of the painting – and use clean absorbent paper to take excess moisture from the brush

Graded washes

Tilt the top of your painting board approximately ten degrees up from the horizontal. Wet the paper all over and then stroke a brush loaded with a strong colour wash horizontally across the top. Dilute the colour slightly and lay in another stroke of colour, slightly overlapping the first one. Work quickly down the sheet applying more strokes of progressively weaker colour. You can also work this technique from the bottom upwards and from side to side.

Blocking in

Blocking in is a simple matter of filling areas of the paper with colour which can then be glazed over with other colours to add shape and form. Flat brushes are eminently suitable for working this technique.

Overlaid glazing

You can use the transparent quality of watercolours to create medium and darker tones simply by glazing a second layer of wash over a dry first layer. However, you must work briskly, yet lightly, so as not to disturb the first wash. This technique is especially useful when painting shadows.

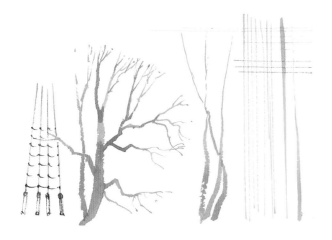

Fine lines

I use a rigger for most fine lines. The original use for this brush was, as its name suggests, for painting the rigging on boats in marine pictures. However, in landscapes, it is especially useful for painting tapering branches and twigs on trees. The brush is usually held upright and line thickness is changed by varying the downward pressure. Work a tapered line from the thick end out to the fine tip. Again, practise makes perfect.

Wet into wet

Some exciting results can be achieved with this technique. Wet an area of the paper with clean water and then drop in various colours. Tilt the painting board to different angles and allow the colours to flow into each other. This type of painting is very much a matter of timing – practising and experimenting will pay dividends. You can also use this technique on a smaller scale to create subtle blends of colour on, for example, the foliage of a tree.

Dry-brush work

Try using your brushes in different ways, with different paint consistencies and on different paper surfaces.

Dry-brush work is the technique of lightly dragging or pushing a brush loaded with 'dry' paint (a mix that is high in pigment and low in water) across the surface of the paper to take full advantage of its texture. Vary the applied pressure and note the various marks and effects you can achieve.

Understanding tone

The variation of tonal value, in terms of the dark and light areas of a subject, is an important aspect of any painting. One way of appreciating tone is to look at a scene through half-closed eyes – the more you close them, the greater is the contrast between light and dark. Painting in monochrome (using diluted shades of just one colour) helps you understand the importance of tone. Any colour can be used, but a dark colour which dilutes down to almost clear is best. Sepia is one such colour.

Farmhouse

This is a good subject for a monochrome painting as there is a strong source of light (coming from the left) that creates contrasting areas of light and dark. It also includes flat surfaces with different tonal values, a few trees silhouetted against a clear sky, and strong foreground shadows that give depth to the scene.

When painting watercolours, whether in monochrome or a range of colours, try to work from top to bottom, from light to dark and from background to foreground. I painted this demonstration on a 380 x 280mm (15 x 11in) sheet of 425gsm (200lb) Rough paper.

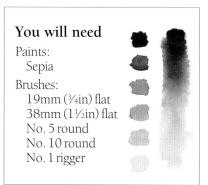

You will need

Paints:
 Sepia
Brushes:
 19mm (¾in) flat
 38mm (1½in) flat
 No. 5 round
 No. 10 round
 No. 1 rigger

Although I do much of my painting on site, I usually make one or two pencil field sketches for future reference. I use these to decide on composition, direction of light and the position and shape of shadows. I also take a few photographs in case my activities are curtailed by unforeseen circumstances – a change in the weather or lighting, or even someone blocking my view with a large truck!

1. Fix the paper to the painting board and use the field sketch as a reference to lightly pencil in the outlines of the main elements of the picture. Then, use the 38mm (1½in) flat brush and clean water to wet all the paper except the farmhouse which, for the moment, is left dry.

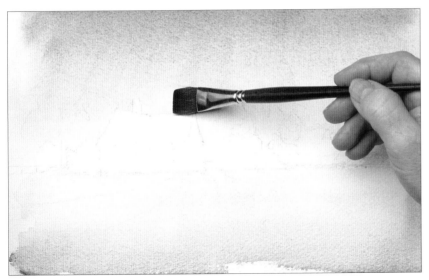

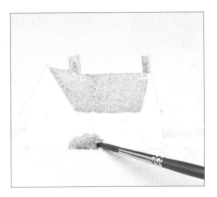

2. Use the 19mm (¾in) flat brush to lay a wash of diluted sepia over the wet areas. Apply stronger tones of colour towards the top and bottom of the picture to accentuate perspective. Leave to dry.

3. Use a No. 5 round brush and a slightly darker tone of colour to paint the distant horizon. Add more colour, then paint the roof and chimneys, leaving highlights for the flashing. Use an even darker tone to paint the small bush in front of the farmhouse.

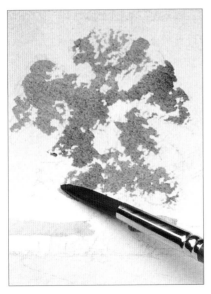

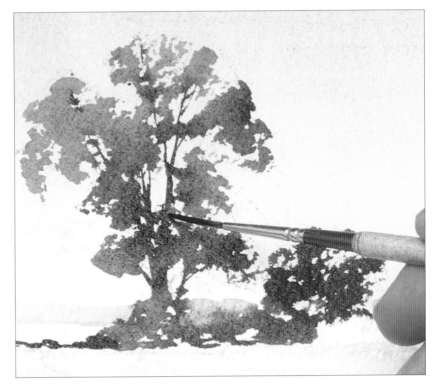

4. Now, working up from light to dark tones, use a No. 10 round brush to paint the foliage on the trees. Lightly drag the side of a loaded brush across the dry paper, allowing areas of the paper to show through. Use the same dry-brush technique to add the bushes at the base of the tree.

5. Use the rigger brush to paint the trunk and branches. Push the brush down on to the paper for the thicker part of each branch and then gradually lift it as the branch gets progressively thinner. Paint the left-hand tree in the same way.

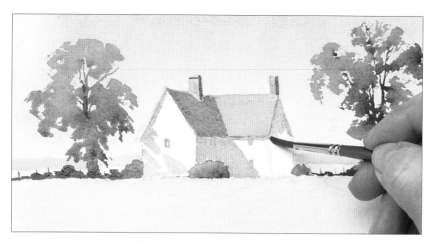

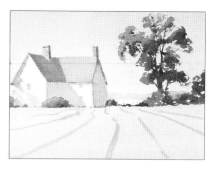

6. Use the No. 5 brush to glaze a shadow over the left-hand roof, then paint the shadows on the walls and gable end of the farmhouse.

7. Paint the furrows that lead the eye into the painting, with a mid tone. Use small touches of a darker tone to create light, shade and form in the trees and other features.

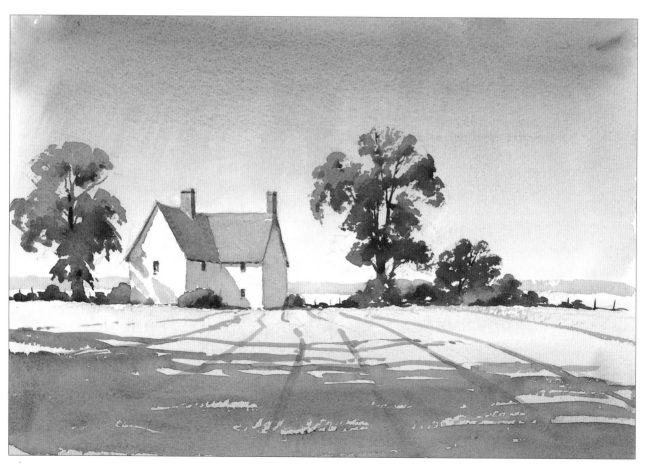

The finished painting

Broad strokes of a loaded No. 10 brush were used to lay in the foreground shadows. Some of the lighter undertones were allowed to peep through and create a feeling of dappled light over rough ground. Although the furrows naturally lead the eye into the picture, darkening the foreground emphasises the sunlit area in the centre of the painting and lifts the eye to it.

18

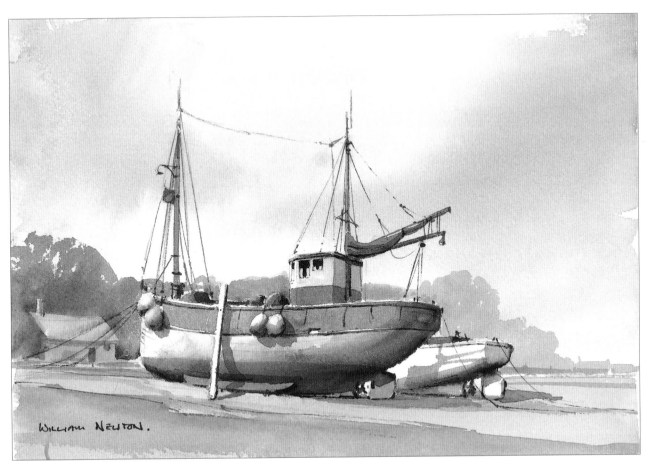

Fishing Boats

280 x 190 mm (11 x 7½in), 425gsm (200lb) NOT

This picture was painted in the same way as the demonstration opposite. Again, the light source is coming sharply from the left.

It might be fun to paint other studies using a different colour. Try burnt umber for a warm effect, or use a cool colour such as a blue to create the impression of a night-time scene.

Note *If I do not like my first attempt at a painting, I do another version of the same subject immediately afterwards, while any mistakes I made are still fresh in my mind.*

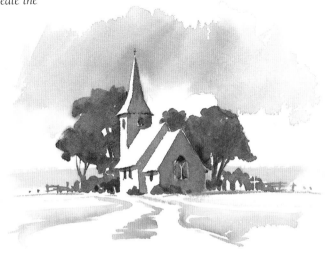

Monochrome study of a country church.

Composition

Old and well-tried maxims like the rule of thirds and painting from light to dark, background to foreground, are sound advice, but like all rules they can be broken. All elements of a composition should contribute to the main focal point – tone, brightness of colour, colour temperature (warm near the centre and cool at the edges) and contrast should all be subservient to the main focal point.

Rule of thirds

In simple terms, this means that the horizon and focal point are better placed somewhat off-centre. The horizon line should be approximately one-third up from the bottom (or one-third down from the top) of a picture, and the main focal point or element within the composition should also be placed one-third in from one side. This is all good advice but, like all rules, it can be broken occasionally.

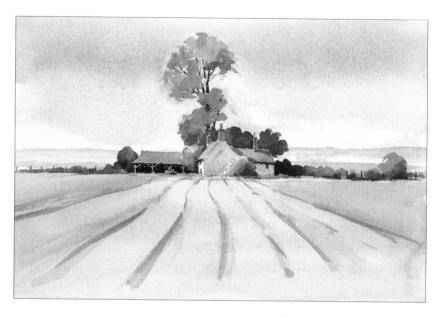

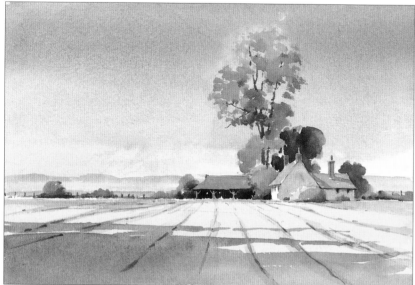

These two paintings show how you can improve a composition by adjusting the positions of the horizon and focal point.

In the composition above, the farm buildings are placed in the centre of the painting, and the large tree appears to cut the image in half. The centred horizon leaves a large expanse of uninteresting foreground.

Although the painting shown left was painted from the same viewpoint as the one above, this version has a well-balanced composition. The focal point is offset to the right and the horizon is roughly one-third up from the bottom. The introduction of deep shadows in the foreground helps draw the eye into the painting.

Perspective

The most difficult aspect of painting is interpreting what we see. Most of what we observe is an illusion caused by distance. Linear and aerial perspective are used to help recreate this illusion on paper.

Linear perspective

Physical objects such as buildings and roads do not really taper to a vanishing point, nor do they get smaller in size with distance, they only appear to. This illusion is referred to as linear perspective, and in general terms it means that all parallel lines converge to a point on the horizon. Remember that the horizon must always be at your eye level. The way in which the lines taper depends on your viewpoint relative to the horizon.

I have included these small sketches to illustrate the principles of linear perspective.

Aerial perspective

Distance also affects our visual perception of colour, tones and contrasts. As an object recedes into the distance its colour appears to fade, and this is known as aerial perspective. The trick is to observe these effects carefully and to develop the skill to represent them in a way that is both stimulating and pleasing to the eye. This is a technique that can be exploited (and exaggerated) to make truly three-dimensional images.

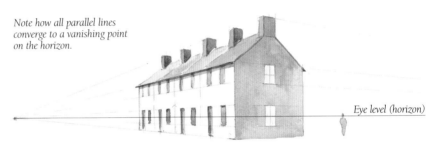

Note how all parallel lines converge to a vanishing point on the horizon.

Eye level (horizon)

In this sketch the viewer and the buildings are on the same flat ground. Although you can see the left-hand point on the horizon, the right-hand one is right off the edge of the paper.

Note the scale of the figure relative to the doors on the building, and that his eye level is also on the horizon line.

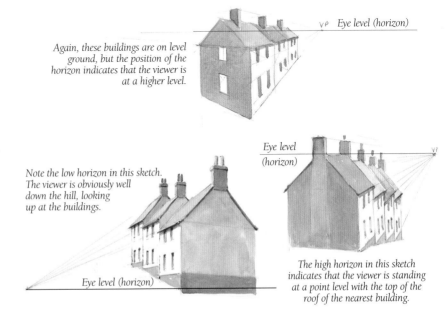

VP Eye level (horizon)

Again, these buildings are on level ground, but the position of the horizon indicates that the viewer is at a higher level.

Eye level (horizon) *VP*

Note the low horizon in this sketch. The viewer is obviously well down the hill, looking up at the buildings.

Eye level (horizon)

The high horizon in this sketch indicates that the viewer is standing at a point level with the top of the roof of the nearest building.

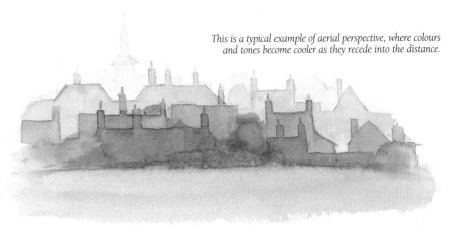

This is a typical example of aerial perspective, where colours and tones become cooler as they recede into the distance.

Skies

The sky often provides the setting for a picture, and it should always be considered as part of the overall composition. The type of sky you paint rather depends on the subject, the kind of scene you are trying to represent, and the other elements that are to be included.

If the composition is high in content, with architecture, trees or boats providing strong verticals, and if it has plenty of middle distance and foreground interest, there is a good case for having a relatively simple sky. If, on the other hand, the focal points are distant and flat, then perhaps a low horizon and a dramatic cloud formation might be called for. On these pages I have included a few sketches where the sky is a fairly dominant element of the picture.

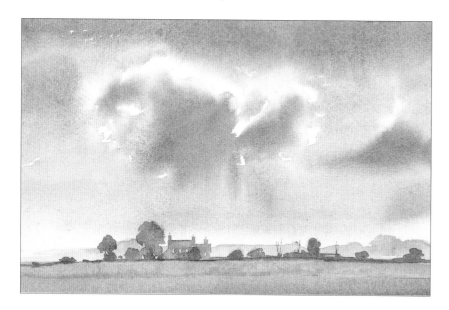

Storm clouds

This sky is painted wet on dry, with some areas of the paper left white to denote highlights.

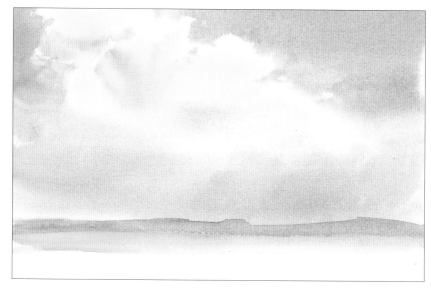

Evening sky

Here, the sky is painted wet into wet, with warm tones graded from the bottom to the top of the clouds.

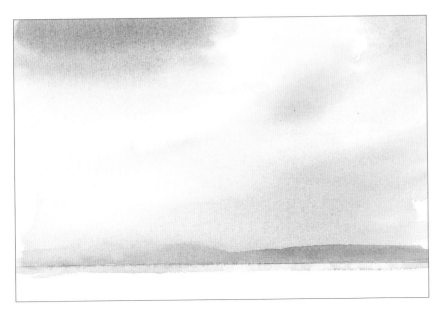

Morning mist

Again, this sky is painted wet into wet. Note the use of violet tones that are laid across the lower sky and into hills on the horizon.

Sunset

Hardly any blue has been used for this sky. Warm mixes of raw sienna and cadmium red are painted wet into wet. The setting sun is left dry at first, then a touch of dilute cadmium yellow is painted into it.

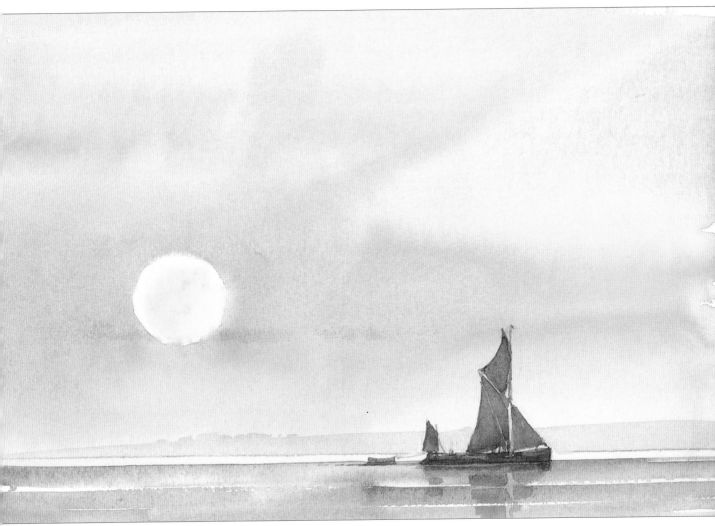

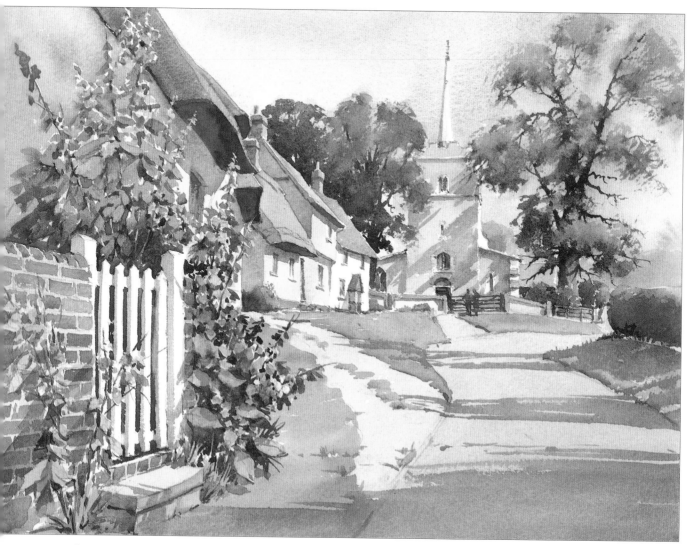

Sunday Morning

370 x 275mm (14½ x 10¾in), 425gsm (200lb) Rough

In this painting of a village church and its approaches, maximum use has been made of linear perspective. Note how the gate appears to be very large relative to the church. Note also the steepness of the roof angles on the nearest cottage. Since there is only a relatively short distance between the viewpoint and the church, very little opportunity exists to use aerial perspective. Even so, the more detailed technique used to paint the gate and its surrounding flowers contrasts well against the softer and weaker tones that are used for the cottages, church and trees.

Opposite

The Shambles, York

185 x 260mm (7¼ x 10¼in), 300gsm (140lb) NOT

This world-famous street is a favourite subject for many artists. The long narrow street with its old timber-framed buildings provides an ideal opportunity to experiment with both linear and aerial perspective. In this painting, the deep foreground shadows contrast well with the obviously bright sunlight at the far end of the street. Note how the colours and tones get progressively weaker with distance. Note also how the form (detail) needed to suggest the buildings gets more vague.

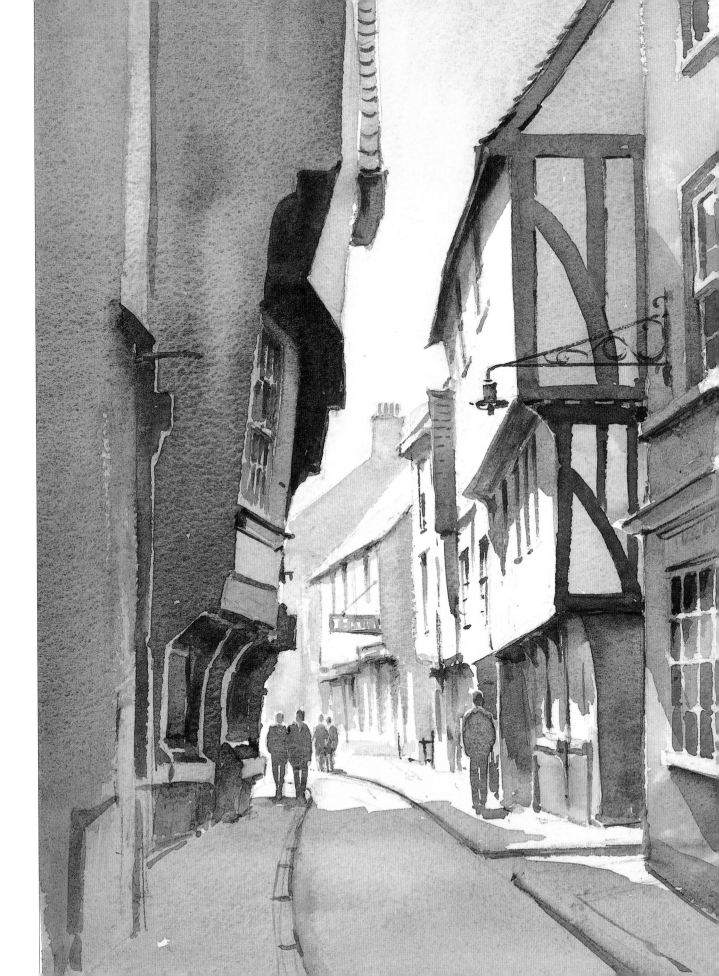

Using a limited palette

Painting with a limited palette is a good way to develop your mixing skills. I have already shown you how it is possible to create a wide range of tones with a single colour. Now, I want to show you how you can create a multitude of colours and tones from just a few colours. Any trepidation you might feel at the prospect of working with a limited palette will soon be dispelled, as it is actually much simpler than you might first think. Since there are only a few colours available, a lot of the usual decision-making about which colour to dip into next, will be considerably eased.

Village Lane

A simple landscape is ideal for painting with a limited palette. For this demonstration I use three colours – red, yellow and blue. These can be mixed with each other to create a wide range of harmonious colours. I painted this picture on a 380 x 280mm (15 x 11in) sheet of 300gsm (140lb) Rough watercolour paper.

Field sketch.

You will need

Paints:
Raw sienna
Light red
French ultramarine
Brushes:
19mm (¾in) flat
38mm (1½in) flat
No. 10 round
No. 1 rigger

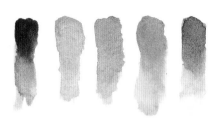

Raw sienna, light red and French ultramarine can be mixed with each other to create a wide range of colours.

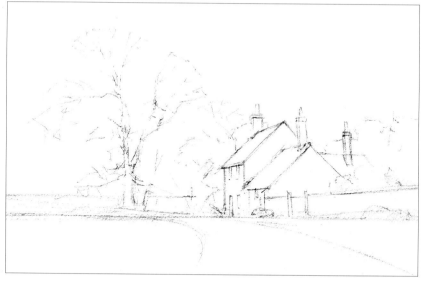

1. Use the field sketch as a reference to lightly pencil in the main elements of the landscape, then wet all the sky area using the 38mm (1½in) flat brush.

2. Mix French ultramarine with a touch of light red, then use the 19mm (¾in) flat brush to lay in the blue areas of sky, fading the colour as you work down towards the horizon. Add a weak wash of light red to the distant sky. Add touches of raw sienna and light red to the lower sky and the base of the clouds.

3. Paint the foreground area with a weak wash of raw sienna.

4. Use the No. 10 round brush and a mix of French ultramarine and light red to paint in the distant horizon.

27

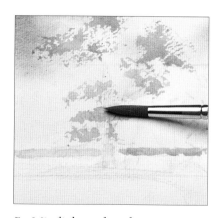

5. Mix light red and raw sienna to make a slightly-warm yellow, then use the dry-brush technique to start painting the foliage on the left-hand tree.

6. Add a little French ultramarine to the yellow mix, then add some darks to the foliage to depict shadowed areas. Allow the colours to run together.

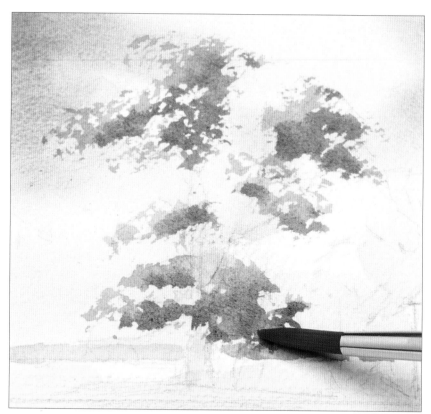

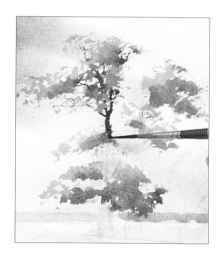

7. Add more French ultramarine to the mix, then use a rigger brush to paint the branches of the tree.

8. When you have worked all the branches with the rigger, use a No. 10 round brush to paint the thick tree trunk.

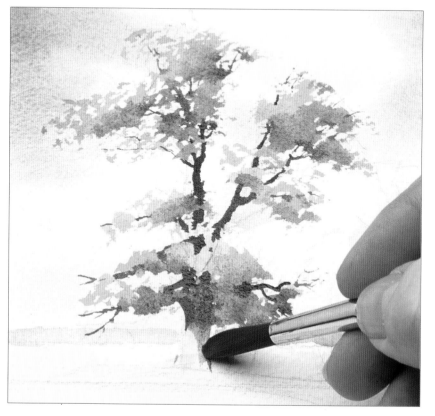

9. Mix a dilute wash of light red with a touch of raw sienna, then block in the chimneys and two roofs. Leave small white areas as highlights on the lead flashing. Strengthen the tone for the small roof at the back of the building. Wash tones of light red over the walls of the building, leaving a few small white highlights on the brickwork.

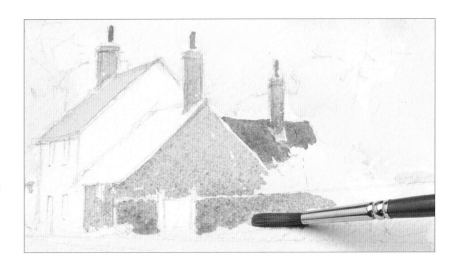

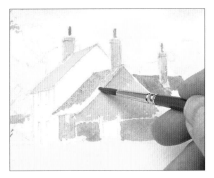

10. Use a dilute wash of French ultramarine to block in the roof of the nearest building.

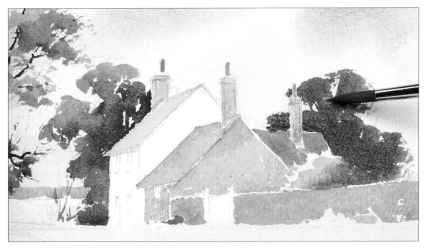

11. Use all three colours to mix tones of green, then use the side and tip of the brush to paint the trees on each side of the buildings – allow the colours to run into each other. Add touches of red to the foliage.

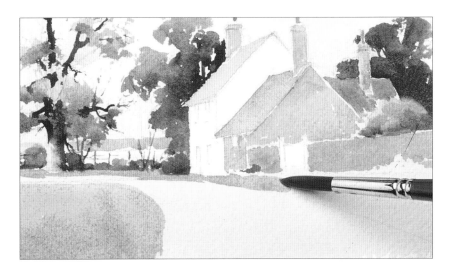

12. Use the same dark tones to paint the hedgerow at the end of the buildings. Use the tip of the brush to add the fence posts. Then, use a mix of raw sienna with a touch of French ultra-marine to block in the foreground grasses on each side of the lane.

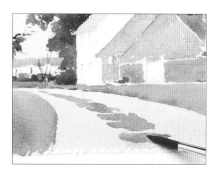 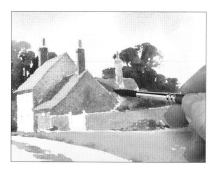 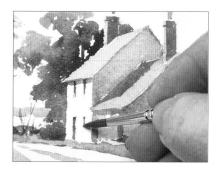

13. Use the dry-brush technique and a mix of raw sienna and French ultramarine to paint the grass in the centre of the lane.

14. Mix French ultramarine with a touch of light red and paint in the shadows on the buildings.

15. Paint in the door with light red, then add a touch of French ultramarine to the windows.

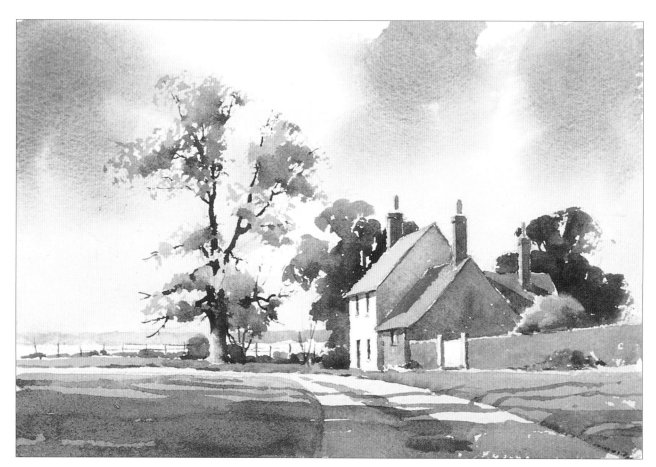

The finished painting
Fine details, and small, dark accents of colour were added to the main tree, the gutters of the buildings, the gate and the fence posts. Finally, using a bold hand and a brush loaded with a fairly strong, but fluid, mix of French ultramarine and light red, the long evening shadows were laid left to right, across the lane and lower part of the composition.

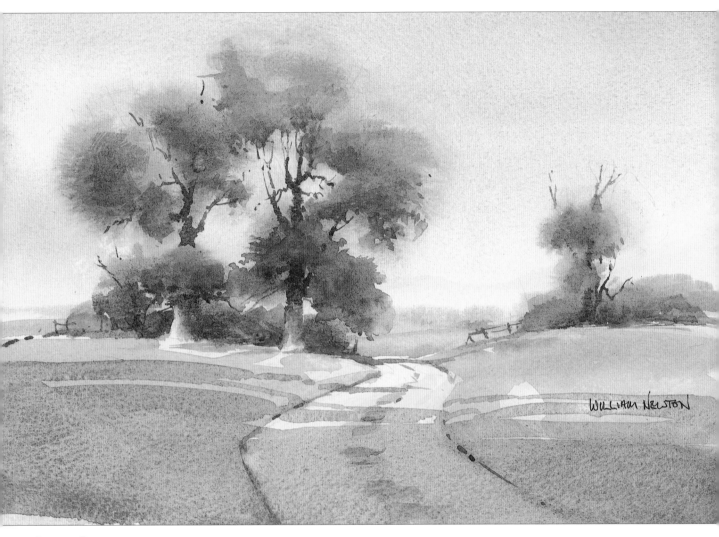

Autumn Lane

270 x 180mm (10½ x 7in), 300gsm (140lb) NOT

This is another example of painting with a limited palette. Again, I used just three colours – cobalt blue, burnt sienna and raw sienna – on a cream paper. Note the extensive use of the wet-into-wet technique for the foliage in this painting.

Note *Even when you expand your palette to eight or more colours, it is more than likely that approximately ninety per cent of your painting will be covered by just three or four colours.*

Painting trees

Tree painting is an essential part of the landscape painters' armoury, and there can be few subjects more challenging or more rewarding. The more you practice the better! How you paint trees will depend on how they feature in your composition – they may be just distant smudges on the horizon, beautiful shapes (but with little form) in the middle distance, or detailed foreground objects. It is really a matter of emphasis.

The trees surrounding the farmhouse on page 30, for example, are merely supporting elements and, consequently, they are rendered with a simple, almost flat wash. On the other hand, if a tree is the main subject of a composition (see pages 37 and 38) it will require more treatment and detail.

Trees come in all shapes and sizes, and I like to make lots of sketches of them during the different seasons of the year. Seeing the bare bones of deciduous trees in winter will help you clothe them with foliage. I have included these sketches of trees to show just a few of the many shapes and textures you can create.

Tree in winter

A dead tree, or one depicted in winter without its foliage, is best painted from the ground upwards. Even so, you might still need a very light pencil line around its outer shape to show how it will fit into a composition. Exploiting differing tones, one branch against another, will help to make a tree into a three-dimensional object.

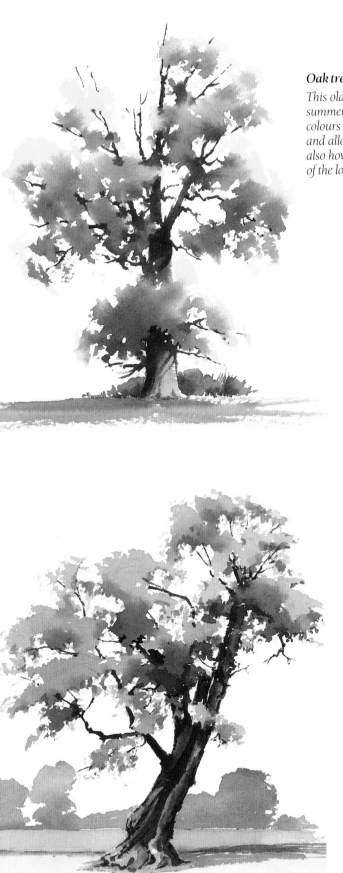

Oak tree

This old oak tree was painted very rapidly, wet into wet, in late summer. The foliage was painted in first then, while these colours were still wet, the dark branches and twigs were run in and allowed to merge slightly (see also pages 36 and 37). Note also how the ground shrubbery contrasts with the pale colours of the lower trunk.

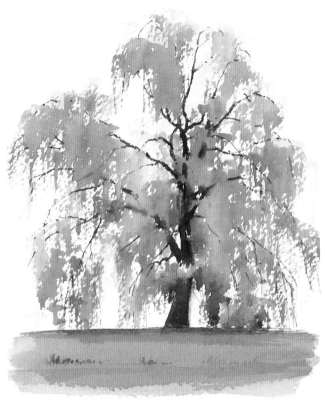

Willow tree

Weeping willow trees are a joy to paint as they have a good, expansive branch structure and interesting foliage. The bulk of the foliage was painted wet into wet, then allowed to dry. The long trailing strands of foliage were then added using the dry-brush technique, dragging the brush strokes vertically downwards.

Walnut tree

Always look for trees with interesting shapes. You do not just want to paint sticks of candyfloss! This ancient walnut tree has an almost hollow trunk and looks rather windswept. Make sketches as often as possible and then add them to a composition when the available trees are not that interesting.

Tree in the Landscape

In this demonstration of an old oak tree in a landscape, I use a combination of techniques – loose free washes, dry-brush work and fine line work with a rigger brush. I have also added two more colours to the palette. I painted this demonstration on a 380 x 280mm (15 x 11in) sheet of 425gsm (200lb) Rough paper.

Field sketch. Although this sketch is quite detailed, I transfer the minimum of detail to the watercolour paper – the horizon line, the general outline of the tree and the position of its trunk.

You will need

Paints:
Cobalt blue
French ultramarine
Light red
Raw sienna
Lemon yellow

Brushes:
19mm (¾in) flat
38mm (1½in) flat
No. 10 round
No. 12 round
No. 1 rigger

1. Use the 38mm (1½in) flat brush and clean water to wet the paper down to the horizon. Mix a wash of French ultramarine, cobalt blue and a touch of light red, then use the 19mm (¾in) flat brush to lay in the sky. Make broad strokes across the paper and allow the colour to fade towards the horizon.

2. Add a little light red to the sky mix and continue to lay in the wash, warming the colours as you move downwards.

3. Add a touch of dilute raw sienna to the mix and lay in the final stroke across the horizon.

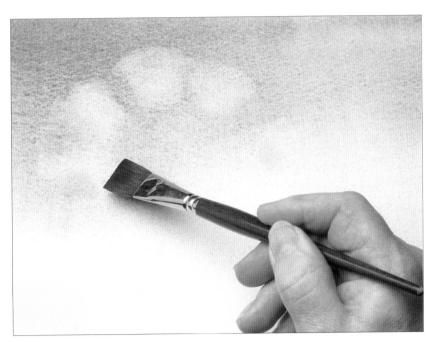

4. Next, start to paint the foliage of the tree. Thoroughly clean the brush and place small areas of raw sienna (mixed with a touch of water) into the still-wet blue sky. You will find that the raw sienna repels the blue and leaves a warm undercolour over which the foliage can be developed. The brush lifts out some of the blue, so rinse it well and load fresh colour for each area.

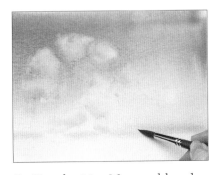

5. Use the No. 10 round brush and a mix of cobalt blue with a touch of light red to paint in the distant horizon while the paper is still damp.

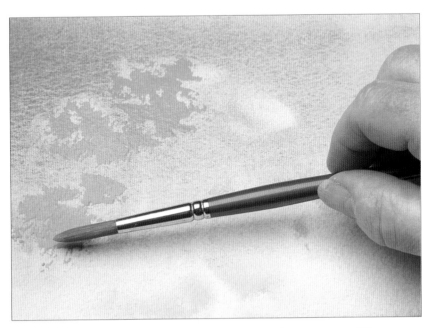

6. Make up a dryish green mix from French ultramarine and lemon yellow, with touches of raw sienna and water. Use the side of the brush and the dry-brush technique to start building up the foliage.

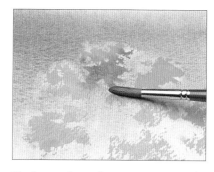

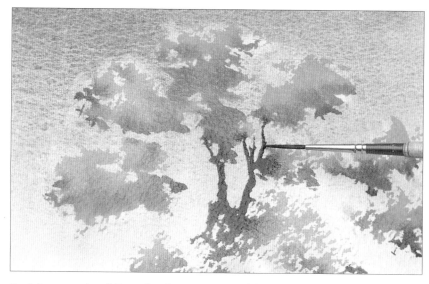

7. Strengthen the green mix with a little more French ultramarine then, bearing in mind the position of light source, drop this into the wet foliage to create shadowed areas.

8. Mix a wash of French ultramarine and light red to create a neutral grey and, while the foliage is still wet, use the rigger brush to paint the upper part of the tree trunk and the thicker branches.

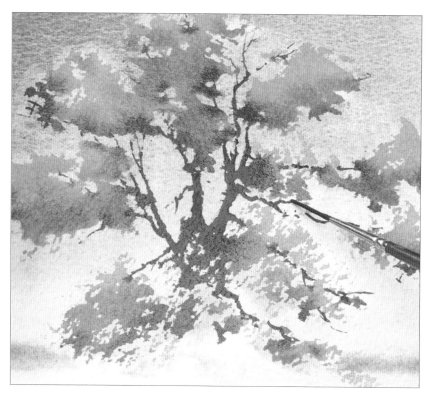

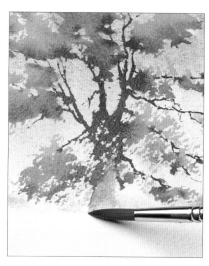

10. Using the same mix, and the No. 10 round brush, run colour into the tree trunk. Dilute the tone on the right-hand side to create form.

9. Continue to add more branches, allowing some of the darker colour to run into the greens of the foliage. Remember that branches get progressively thinner towards their tips, so start each stroke with the rigger held down and then gently lift it to the tip.

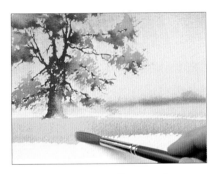

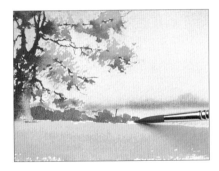

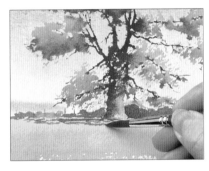

11. Mix lemon yellow with touches of French ultramarine and raw sienna, then use the No. 12 round brush to lay broad strokes of colour across the foreground area.

12. Mix French ultramarine, lemon yellow and light red, then use a No. 10 round brush and random, short downward strokes to lay in the hedge behind the tree. Vary the tones to create light and shade.

13. Mix French ultramarine with a touch of light red and use the tip of the brush to add the fence posts. Dilute the mix slightly, then add shadows to the trunk and across the grass at the base of the tree.

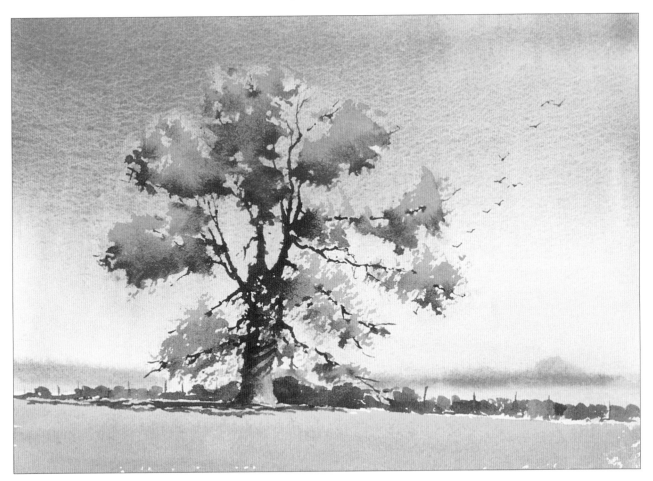

The finished painting

Cast shadows were added to the trunk of the tree to emphasize the right-to-left light source. Finally, the tip of a rigger brush was used to add a flock of birds in the sky – this complements this simple composition.

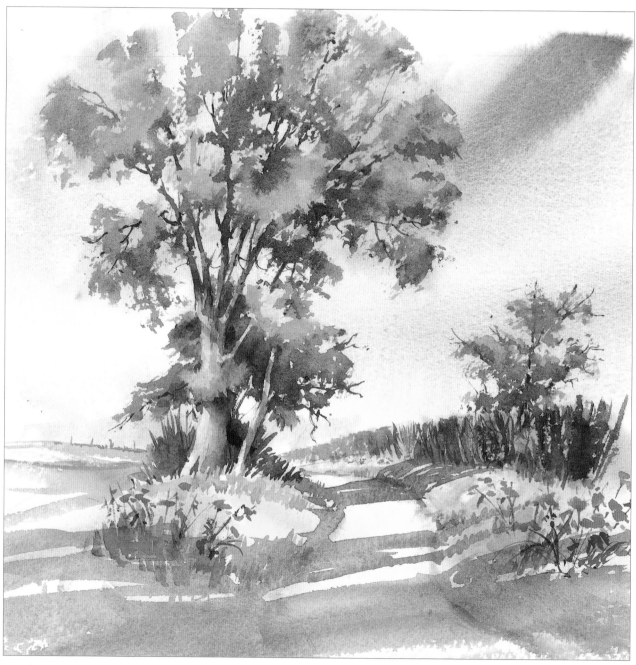

Sunshine and Shadows
255 x 255mm (10 x 10in), 425gsm (200lb) Rough

This painting is very much a tree portrait. The bright red flowers in the foreground capture the viewer's attention, and the shape of the road draws the eye into the picture.

Opposite
Morning Ride
245 x 305mm (9½ x 12in) 640gsm (300lb) NOT

This is a painting composed and painted in my studio from visual notes gathered earlier. The riders and their horses were painted quite freely to try and convey a sense of movement.

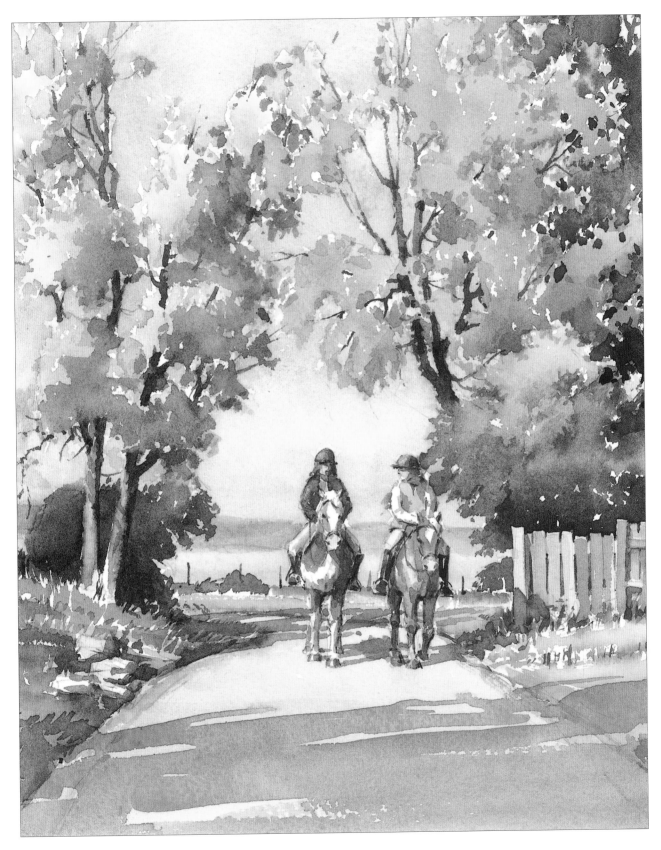

Painting water

Painting water is perhaps one of the most daunting challenges for the beginner. However, it need not be too big a stumbling block. As always, the trick is to observe carefully and to paint what you see: a dark area here and a light area there; light tones, half tones and full tones. Although water is generally regarded as colourless, it acts as a mirror and reflects colours from all around it. On these pages I try to show how I treat various forms of water.

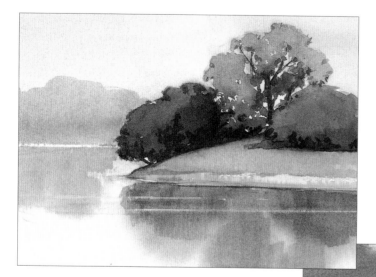

Still waters

In very still water, reflections are almost mirror images of the objects behind the water. However, they should have a slightly fuzzy look to them and the reflected colours should be less intense.

Rippled reflections

This boat is moored on water that has a slight ripple on its surface. Note how the reflection of the boat is a little distorted and 'wobbly'. Note also how the light colours of the boat are slightly darker in its reflection.

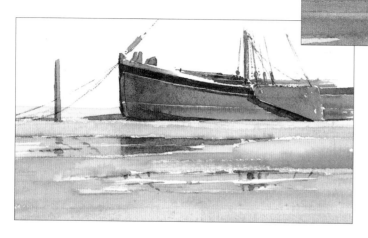

Puddles

A little artistic licence is often required when painting puddles. You need to place them strategically so that they reflect verticals – in this case, the post and the stem of the barge.

Moving water

Movement in water is perhaps the most difficult subject to capture. Again, observation is the key. In a choppy sea, the tones of each wave appear darker towards the top and lighter in the troughs. Sometimes, white paper can be left to represent the 'white horses' of breaking waves. Compare this sketch with that of the moving water in a waterfall.

Waterfall

For this type of rushing water, the trick is what you do not paint, rather than what you do paint! In other words, most of the water is just white paper, with just a few softened brush strokes to add reflections as appropriate.

Wet road

The method here is similar to that used for the rippled water. Roads are not perfectly flat, so reflections will be slightly distorted across the surface.

It is worth taking care to ensure that reflected details such as windows, vertical lines and figures, are positioned accurately.

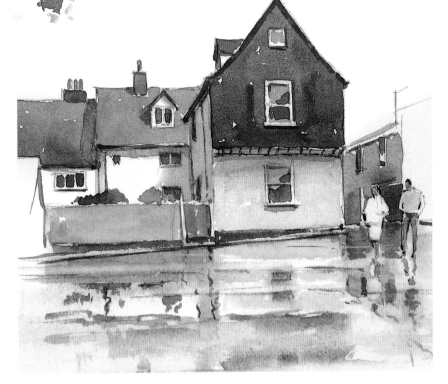

Fishing Boat

There has always been a strong tradition of marine painting among watercolourists and it remains as popular as ever. For this final step-by-step demonstration I paint an old fishing boat riding at anchor. I use eight colours and a 380 x 280mm (15 x 11in) sheet of 425gsm (200lb) Rough paper.

There are special problems associated with painting boats, not least of which is drawing the craft accurately in the first place. It is said that 'under every good painting there is a good drawing', and never a truer word has been spoken. As ever, good observation and lots of practice is the key. I find it helpful to imagine that I am looking right through the hull, in x-ray fashion, so that I can see the lines of the craft on the other side and how they link up with those on the visible side.

Water reflections should hold no fears – with a simple but bold approach, it is relatively easy to achieve a convincing effect.

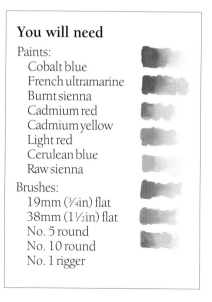

You will need

Paints:
 Cobalt blue
 French ultramarine
 Burnt sienna
 Cadmium red
 Cadmium yellow
 Light red
 Cerulean blue
 Raw sienna

Brushes:
 19mm (¾in) flat
 38mm (1½in) flat
 No. 5 round
 No. 10 round
 No. 1 rigger

Field sketch showing the structure of the vessel and its reflections.

1. Lightly draw the main outlines of the fishing boat and its tender, then use the 38mm (1½in) flat brush to wet all the sky area except the wheelhouse, which must be left dry for the moment.

2. Mix French ultramarine, cobalt blue and light red, then use the 19mm (¾in) flat brush to wash in the sky, making the tone lighter towards the horizon. Leave some areas unpainted for clouds.

3. Add a touch of light red towards the horizon and allow some of the colours to run together. Wash raw sienna into the cloud areas.

4. Paint in the darker areas of water, leaving some white areas to represent ripples. Use a clean damp brush to lift out some of the blue paint where the clouds are reflected in the water.

5. Use the No. 10 round brush and the same blue mix to paint the distant headland.

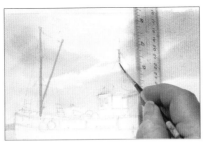

6. Use the rigger brush and burnt sienna to paint the mast and spars. Run the brush along the edge of an angled ruler to help keep lines straight.

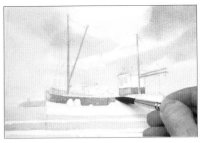

7. Use the No. 10 round brush to paint the interior of the boat with a pale wash of raw sienna. Then, block in the lower part of the cabin and the upper hull with cerulean blue – dilute the mix where the light catches the bow.

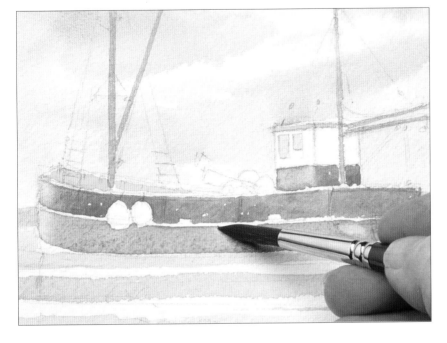

8. Use a mix of cadmium red and cadmium yellow to paint the cabin roof. Block in the lower hull with burnt sienna, then wash in a little burnt umber. Lift out some of the colour near the bow to create form and highlights.

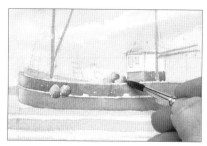

9. Use a mix of cadmium red and cadmium yellow to paint the floats and marker flags. Vary the tone to create form.

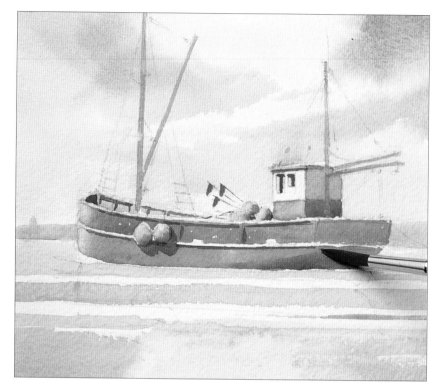

10. Use tones of French ultramarine and light red to paint the shadows and fine details inside the boat, and on the outside of the hull. Dilute the mix slightly and darken the shaded stern of the boat.

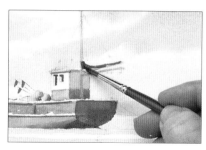

11. Use the No. 5 round brush and French ultramarine to paint the furled sail.

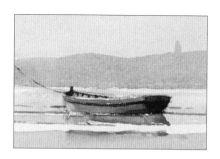

12. Paint the tender using the same techniques as described in steps 6–10.

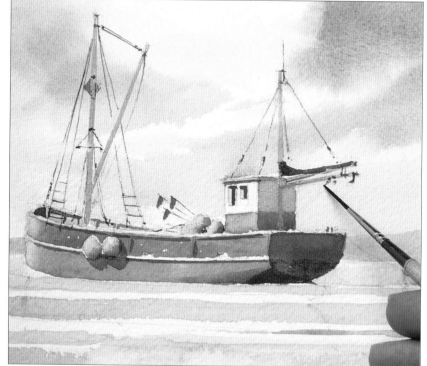

13. Mix French ultramarine with some light red, then use the tip of the rigger brush to paint in the rigging.

14. Mix French ultramarine with raw sienna, then use horizontal strokes of the No. 10 round brush to lay in the darker ripples in the water. Leave long, irregular strips of paper untouched to represent disturbed water. When dry, paint in the reflections using mixtures of colours which suggest those of the boat. Notice that the reflections only occur in the darker strips of water, and that the colours are somewhat diminished within the reflections.

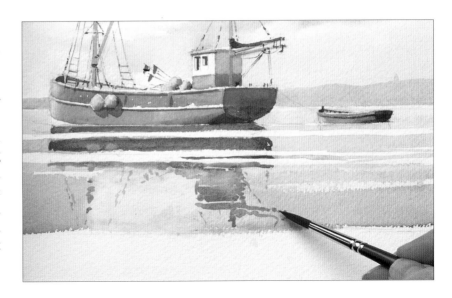

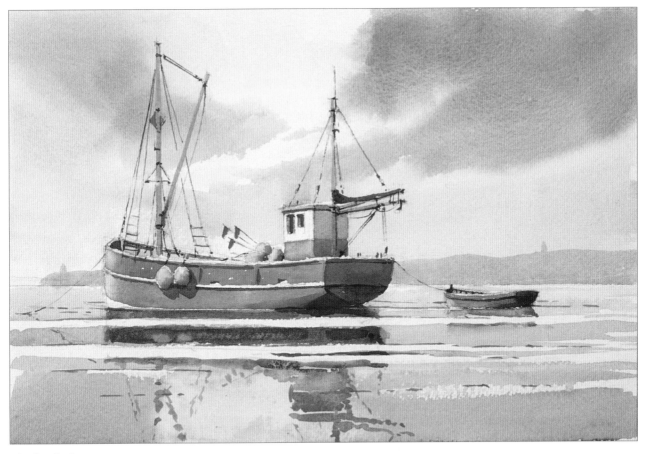

The finished painting
Note how the sky has been painted to balance and complement the overall composition.

WILLIAM NEWTON

Morning Glory
560 x 380mm (22 x 15in),
640gsm (300lb) NOT

This large studio painting on heavyweight paper was the result of sketches and other pictures painted in situ at one of my favourite locations. The dark, distant landscape was painted first and then the sky washes were brought down over it to create recession. The watery sun was lifted out with a clean but damp brush. Extensive use of raw sienna washes gives the painting a warm atmospheric glow.

Index

Riverside Peace
380 x 280mm (15 x 11in),
300gsm (140lb) Rough

In this painting, the light is coming more or less straight towards the viewer, backlighting the group of boats and throwing them into silhouette. My aim was to render the sense of peace that low water brings with it.

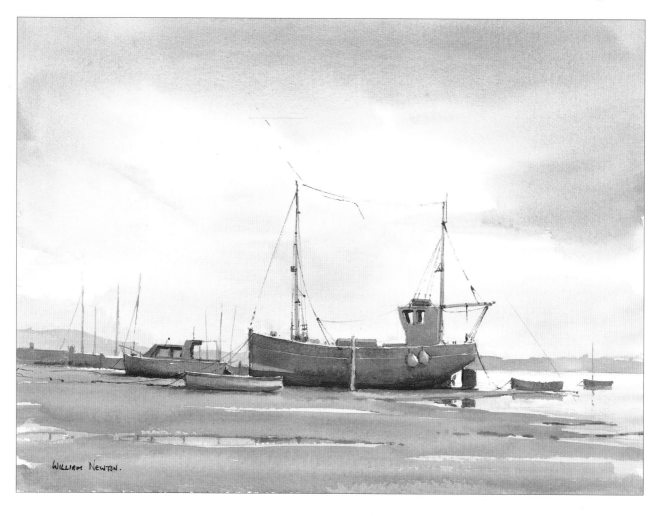